Presented to

...

From

...

Date

...

Redeemed

A
Prayer & Praise
Journal

Redeemed

A
Prayer & Praise
Journal

BARBOUR
PUBLISHING

© 2021 by Barbour Publishing, Inc.

ISBN 978-1-64352-890-8

Text compiled from *Everyday Praise* by Vicki J. Kuyper; *Everyday Prayers* by Rachel Quillin; and *Praying Your Way to Hope* by Jessie Fioritto. All rights reserved.

Published by Barbour Publishing, Inc., 1810 Barbour Drive, Uhrichsville, Ohio 44683, www.barbourbooks.com

Our mission is to inspire the world with the life-changing message of the Bible.

 Member of the
Evangelical Christian
Publishers Association

Printed in China.

You have been redeemed!

"Do not fear, for I have redeemed you;
I have summoned you by name; you are mine."
Isaiah 43:1 NIV

This prayer and praise journal is a delightful way to celebrate your faith and the God who calls you His.

With every turn of the page, you will encounter devotions, prayer starters, truth-filled scriptures, thought-provoking prompts, and generous journaling space to record your very own prayers, praises, and personal thoughts.

His Cherished Child

*All sunshine and sovereign is God,
generous in gifts and glory.*
PSALM 84:11 MSG

You have a Father who owns the cattle on a thousand hills and holds the cosmos in His hands. This almighty Father generously offers all He has to you. He offers you a life overflowing with joy, comfort, and blessing. But like any gift, this one has to be accepted before it can be enjoyed. Today, why not say yes to the Father who loves you? Tell Him how you long to live—and love—like His cherished child.

Praying Today

I know You'll take care of me, Father. And, although I might not fully experience wealth in this life, Your Word is a loving reminder that I have amazing riches to anticipate in eternity with You!

Praising Today _____

WHOLEHEARTED ACCEPTANCE

The LORD has heard my cry for mercy;
the LORD accepts my prayer.
PSALM 6:9 NIV

People talk about "accepting" God into their lives. But it's God's acceptance of us that makes this possible. Because Jesus gave His life to pay the price for all the wrongs we've ever done, our perfect God can accept us wholeheartedly, even though we're far from perfect people. God not only accepts us, but He also accepts our imperfect prayers. We don't have to worry about saying just the right words. The "perfect" prayer is simply sharing what's on our hearts.

Praying Today

Salvation is something all human beings long for in one way or another, Father, and the salvation You've provided far surpasses anything that could be presented by mankind. You've rescued me from the depths of sin and given me new life in Christ, and I will ever praise You!

Praising Today

You Are Worthy

*You make your saving help my shield, and your right
hand sustains me; your help has made me great.*
PSALM 18:35 NIV

Accomplishing something worthwhile is one of the joys of living. It can give you a sense of purpose and worth. But you are more than the sum of your accomplishments. You are an accomplished woman simply by continuing to mature into the individual God created you to be. Enjoy using every gift, talent, and ability God has so generously woven into you while resting in the fact that you are worthy of God's love, regardless of what you've achieved.

Praying Today

..

..

..

..

..

..

..

..

How can I doubt my worth in Your eyes, Father? You know the number of hairs on my head. You created me, and You said that Your creation is very good. When I'm tempted to get down on myself, remind me that I am special to You and that there's no one else just like me.

Praising Today

Reason for Praise

*I praise you because I am fearfully
and wonderfully made.*

Psalm 139:14 NIV

You are a living, breathing reason for praise. God formed only one of you, unique in appearance, intricate in design, priceless beyond measure. You were fashioned with both love and forethought. When you look in the mirror, is this what you reflect on? If not, it's time to retrain your brain. Use the mirror as a touchstone to praise. Ask God, "What do You see when You look at me?" Listen quietly as God's truth helps retool your self-image.

Praying Today _____

You know, Lord, I spend a lot of time each morning trying to look physically attractive. That doesn't do much for my soul though. Sure, I feel better when I look nice, but I know if people saw Your beauty in me, that would bring more joy. Draw me close, Father, and make this a reality.

Praising Today _____

No Greater Assurance

The Lord will work out his plans for my life—
for your faithful love, O Lord, endures forever.
Psalm 138:8 nlt

Throughout scripture, God continually reassures us that He's working on our behalf to accomplish the good things He has planned for our lives. If your confidence wavers, if you need to know for certain someone is on your side, if you're anxious about the future, do what people who've felt the very same way have done for centuries: take God's words to heart. There's no greater assurance than knowing you're loved, completely and eternally.

Praying Today _____

..

..

..

..

..

..

..

..

Dear Father, I'm a far cry from perfect, but I'm confident in the knowledge that You love me just as I am. You are the One who has begun a good work in me, and You will be faithful to complete what has been started. What a thrill to know that You'll make me what You want me to be.

Praising Today _____

Attitude Adjustment

This is the day the LORD has made;
we will rejoice and be glad in it.
PSALM 118:24 NKJV

What kind of day will you have today? Your answer might be "I won't know until I've lived it!" But the attitude with which you approach each new day can change the way you experience life. That's why it's important to set aside some "attitude adjustment time" every morning. When you wake, remind yourself, "This is the day the Lord has made." Look for His hand in the details, and thank Him for every blessing He brings your way.

Praying Today

Father God, the happiness I enjoy when I'm with my family or just relaxing with a good book on a lazy afternoon is beyond sufficient. True happiness can't really be bought, can it? It all comes from You!

Praising Today _____

What You Believe

You have always been God—long before the birth of the mountains, even before you created the earth and the world.
PSALM 90:2 CEV

People once believed the world was flat. This meant only the most intrepid explorers would venture long distances and risk falling off the "edge" of the earth. What people believe determines the choices they make, no matter what era they live in. What do you believe about God? Does it line up with what the Bible says? It's worth checking out. Since you will live what you believe, it's important to be certain what you believe is true.

Praying Today _____

..

..

..

..

..

..

..

..

Lord, You've provided a wealth of wisdom in Your Word, but knowing what's there and acting on it are two entirely different things. Sometimes my behavior is still so foolish. Forgive me, Lord. Help me not to ignore the direction You've given me. Help me to walk wisely.

Praising Today ⸺

A LOVE LETTER

*Every word you give me is a miracle word—how could I help
but obey? Break open your words, let the light shine
out, let ordinary people see the meaning.*
PSALM 119:129–130 MSG

The Bible isn't a novel to be read for entertainment, a textbook
to be skimmed for knowledge, a manual for living, or a collection
of inspirational sayings. The Bible is a love letter. It's the story of
God's love for His children from the beginning of the world until
the end—and beyond. It's a book that takes time to know well; but
God promises His own Spirit will help us understand what we read.
All we need to do is ask.

Praying Today

Love—what a beautiful word! Yet many people are so cynical about it, Father. I guess that's because there is so much artificial affection in this world; but I'd like for people to see true love—Your love—in my life. Please give me the ability to love as You do.

Praising Today

THE PERFECT GIFT

*May God be gracious to us and bless us
and make his face shine on us.*

PSALM 67:1 NIV

When people speak of "blessings," they're often referring to words. Blessings are given at meals and weddings. "Bless you" is often said after a sneeze. The words we speak can be as much of a gift as the blessings we hold in our hands. What would God have you say to the people you meet today? Consider how you can bless others with your words—then speak up. A good word can often be the perfect gift.

Praying Today

Lord, often throughout my day I forget to consult You first. Then I wonder why things don't work out the way I think they should. Forgive my arrogant attitude. I know that only as You guide me through the day will I find joy. Show me how to align my words and actions with Your will.

Praising Today _____

What's Weighing You Down?

Praise be to the Lord, to God our Savior,
who daily bears our burdens.
PSALM 68:19 NIV

Some things are too heavy to carry alone. A couch, for instance. Or a washing machine. The same is true for the mental and emotional burdens we bear. The good news is that strength, peace, comfort, hope, and a host of other helping hands are only a prayer away. We're never alone in our pain or struggle. God is always near, right beside us, ready to help carry what's weighing us down.

Praying Today

Forgive me, Father. Time and again, I've been so stressed that I wanted to give up on life. I tried so hard to get through each day, but I never bothered to give my worries to You. I've fought through each task and brought grief to others by trying to struggle alone; but from now on, I'm casting my cares on You!

Praising Today _____

Challenging Days

The LORD is near to all who call on him,
to all who call on him in truth.
PSALM 145:18 NIV

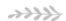

Some mornings you wake up with the knowledge that a challenging day is ahead of you. Other times, difficulty catches you by surprise. Whatever challenge enters your life, remind yourself that the Lord is near. Not only will God help you meet each challenge head-on, but He will use each one to help you grow. Look for God's hand at work in your life, helping you achieve what may seem impossible.

Praying Today _____

..

..

..

..

..

..

..

..

..

Father, I thought challenges were supposed to be positive motivation; but when I woke up this morning, I'm afraid my outlook wasn't very optimistic. All I could think about were the myriad mundane jobs I had to do. Forgive me. Help me to accept each challenge with joy.

Praising Today _____

THE OPPORTUNITY IN CHANGE

I trust in you, LORD; I say, "You are my God."
My times are in your hands.
PSALM 31:14–15 NIV

Change can be exciting. It can also be uncomfortable, unwanted, and at times even terrifying. If you're facing change and find yourself feeling anxious or confused, turn to the God of order and peace. He holds every twist and turn of your life in His hands. Try looking at change through God's eyes, as an opportunity for growth and an invitation to trust Him with your deepest hopes and fears.

Praying Today —————————————————————

You've promised to walk with me all the way and provide all that I need, dear God, and I'm rejoicing in that guarantee. What more do I need? It doesn't matter that the world presents shiny trinkets. Their luster dims in the brilliance of the blessings and contentment that You give.

Praising Today _____

RESPONSE TO ADVERSITY

Only you can say that I am innocent,
because only your eyes can see the truth.
PSALM 17:2 CEV

Not everyone will understand the unseen story behind what you say and do. There will be times when you're misunderstood, slandered, or even rejected. This is when your true character shines through. How you respond to adversity and unfair accusations says a lot about you and the God you serve. Ask God to help you address any blind spots you may have about your own character. Treat your critics with respect. Then move ahead with both confidence and humility.

Praying Today

We humans are by nature very proud, Jesus. Humility isn't something that comes easily. But You are humble, and You are the example I am to follow—regardless of what comes readily. Teach me to be more like You. Teach me to be a servant.

Praising Today _____

Heaven-Sent

Children are a heritage from the LORD,
offspring a reward from him.
PSALM 127:3 NIV

A child is a gift that is literally heaven-sent. You don't have to have children to care about the kids around you—or to learn from them. In the New Testament, Jesus talks about how our faith should resemble that of a child's. To understand why, consider this: children believe what they hear, love unconditionally, and say what they think. What a wonderful way to relate to God!

Praying Today

Children can sometimes be so comical, Lord. They say the funniest things or make the silliest faces. Sometimes all I need to do on a tough day is watch them. They'll do something so hilarious that I can't help but laugh. I feel better right away. Children are a wonderful gift.

Praising Today _____

DECISIONS, DECISIONS

My choice is you, GOD, first and only.
And now I find I'm your choice!
PSALM 16:5 MSG

Some choices we make change the course of our lives, such as whether we'll remain single or marry, what career we'll pursue, whether or not to adopt a child. But there's one choice that changes not only the direction of our lives but also our eternity. When we choose to follow God, it affects every choice we make from that moment forward. The more we involve God in our decision process, the wiser our choices become.

Praying Today _____

..

..

..

..

..

..

..

I'm facing a situation right now, and I'm not quite sure how to handle it, Father. I'm coming to You because I truly lack wisdom, but I need to know how to make the right decision. Thank You for promising that You will guide me.

Praising Today _____

Heart Healing

The LORD is close to the brokenhearted
and saves those who are crushed in spirit.
PSALM 34:18 NIV

Putting your faith in Jesus doesn't mean you'll never have a broken heart. Scripture tells us even Jesus wept. Jesus knew the future. He knew His heavenly Father was in control. He knew victory was certain. But He still grieved. When your heart is broken, only God has the power to make it whole again. It won't happen overnight. But when you draw close to God, you draw close to the true source of peace, joy, and healing.

Praying Today _____

...

...

...

...

...

...

...

...

I know You understand grief better than anyone else, Father, but right now I feel as if no one has traveled this road before me. My sorrow is so deep, my pain so intense. It seems I'm all alone. I need You, God. My soul cries out for relief. Please heal my broken heart and help me smile once more.

Praising Today _____

In Death—and Beyond

He always stands by his covenant—the commitment
he made to a thousand generations.
PSALM 105:8 NLT

God has made a commitment to you, similar to a wedding vow. He promises to love and cherish you through sickness and health, prosperity or poverty, good times and bad. But with God, this commitment doesn't last until "death do you part"—even in death and beyond, God is there. There's nothing you can do that will make Him turn His face from you. His commitment to love and forgive you stands steadfast, come what may.

Praying Today _____

I say I love You, Father, although I'm not sure it goes as deep as it should. I want it to though. I want to be so in love with You that it shows in every aspect of my life. Help me to develop the intimacy with You that I should have.

Praising Today _____

Open Arms

But you, Lord, are a compassionate and gracious God,
slow to anger, abounding in love and faithfulness.
PSALM 86:15 NIV

Without love and compassion, an all-powerful God would be something to fear instead of someone to trust. That's one reason why Jesus came to earth: to help us see the compassionate side of the Almighty. Throughout the Gospels, we read how Jesus reached out to the hurting—the outcasts, the infirm, the poor, and the abandoned. He didn't turn His back on sinners but embraced them with open arms. His arms are still open. Will you run toward His embrace?

Praying Today _____

Why are people afraid to surrender their lives to You, Lord? I know some are fearful that You will ask something of them that they can't bear. Can't they understand that You'll strengthen them through every task? Don't they realize the joy they're missing? God, break down the barriers that hinder Your work.

Praising Today _____

No Fear of the Future

Those who are righteous will be long remembered.
They do not fear bad news; they confidently trust
the LORD to care for them. They are confident and
fearless and can face their foes triumphantly.

PSALM 112:6–8 NLT

We live in uncertain times, economically, politically, and globally. Yet you can greet each new day with your head held high, confident and unafraid. Why? Because you have a God who cares deeply about you and the world around you. When your confidence is placed firmly in God instead of your own abilities, bank account, or "good karma," you need not fear the future. It's in God's powerful, capable, and compassionate hands.

Praying Today _____

...

...

...

...

...

...

...

I love the proverbs, Lord, and one of my favorites says, "Righteousness exalteth a nation" (Proverbs 14:34 KJV). For many years, our country has been powerful among her peers, and it's because You were part of the lives of the people. We've begun to abandon You though. Please forgive us and restore us to a right relationship with You.

Praising Today _____

Following God's Lead

The LORD is my shepherd, I lack nothing.
PSALM 23:1 NIV

When it comes to brains, sheep are not the brightest crayons in the box. They frighten easily, tend to follow the crowd, and have limited abilities for defending themselves—which is why sheep thrive best with a shepherd who guides, protects, and cares for their needs. Our Good Shepherd will do the same for us. Worry, fear, and discontent are products of a sheepish mentality. However, the peace of true contentment can be ours when we follow God's lead.

Praying Today

Father, as I look around, I see so much turmoil. My heart breaks as I watch the trials people attempt to face without You in their lives. They don't realize the perfect peace that You want to give them, and many of them don't want to hear about it. Speak to their hearts. Help them accept Your gift.

Praising Today _____

First, Think

*Wait on the LORD; be of good courage, and He shall
strengthen your heart; wait, I say, on the LORD!*
PSALM 27:14 NKJV

Foolhardiness can look like courage at first glance. However, true
courage counts the cost before it forges ahead. If you're faced
with a risky decision, it's not only wise to think before you act—it's
biblical. Ecclesiastes 3:1 (MSG) reminds us, "There's an opportune
time to do things, a right time for everything on the earth." Waiting
for that right time takes patience and courage. Don't simply pray
for courage. Pray for the wisdom to discern that "opportune time."

Praying Today _____

..

..

..

..

..

..

..

..

..

There are so many how-to books available today, Lord, and they all promise to increase my knowledge in some area. But not one of them gives any hope for added wisdom. Only Your Word offers that. Thank You for providing the means to know You more fully and to live life more abundantly.

Praising Today _____

CLEAN SLATE

Clean the slate, God, so we can start the day fresh!
Keep me from stupid sins, from thinking I can take over your work.
PSALM 19:12–13 MSG

Yesterday is over. Today is a brand-new day. Any mistakes or bad choices you've made in the past are behind you. God doesn't hold them against you. He's wiped your past clean with the power of forgiveness. The only thing left for you to do with the past is learn from it. Celebrate each new day by giving thanks to God for what He's done and actively anticipating what He's going to do with the clean slate of today.

Praying Today _____

Dear heavenly Father, I know You've forgiven me for my wrongs. Though the natural consequences of my sin still hurt and I know they won't disappear, I pray that You will use them in a positive way—perhaps to keep others from making the same mistake. Thank You for the fresh start I have through Your forgiveness.

Praising Today _____

INVITE GOD

I say to GOD, "Be my Lord!" Without you, nothing makes sense.
PSALM 16:2 MSG

Paper or plastic. Right or left. Yes or no. Every day is filled with decisions that need to be made. Some have little bearing on the big picture of our lives, while others can change its course in dramatic ways. Inviting God into our decision-making process is not only wise but also helps us find peace with the decisions we make. Knowing God is at work, weaving all our decisions into a life of purpose, helps us move forward with confidence.

Praying Today _____

..

..

..

..

..

..

..

..

Thank You, Lord, that You have a perfect plan for my life. I know I don't always understand it, but You know what's best. . .and everything that happens is for a reason—that You might be glorified. I'm so glad that You are in control and that I need not worry.

Praising Today _____

Sheer Delight

Take delight in the LORD, and he will give
you the desires of your heart.

PSALM 37:4 NIV

To "delight" in someone is to take great pleasure from simply being in that person's presence. If you truly delight in God, the deepest desire of your heart will be to draw ever closer to Him. This is a desire God Himself delights in filling. That's because God delights in you. You are more than His creation. You are His beloved child. He delights in you like a proud father watching his daughter take her very first steps.

Praying Today _____

Every day there is something for which I can offer You praise, dear God! Throughout the day You show Your majesty in a multitude of ways. You are an awesome God—and You want to spend time with me! I want to spend time with You too, Lord. Draw me close today.

Praising Today _____

DEVOTION

Protect me, for I am devoted to you. Save me,
for I serve you and trust you. You are my God.
PSALM 86:2 NLT

The heart of devotion isn't duty—it's love. The deeper your love, the deeper your devotion. What does being devoted to God look like? It's characterized by a "God first" instead of a "me first" mentality. While it's true that being devoted to God means you'll spend time with Him, it also means you'll give your time to others. Your love of God will spill over onto the lives of those around you. Your devotion to God is beneficial to everyone!

Praying Today _____

..

..

..

..

..

..

..

..

Lord, may the life I live be a continual sacrifice of praise to You. You, who have done so much for me, ask only that I give my life wholly to You. How can I refuse? Let what others see in me cause them to glorify You too.

Praising Today _____

Answered Prayer

The humble will see their God at work and be glad.
Let all who seek God's help be encouraged.
PSALM 69:32 NLT

There's encouragement in answered prayer. Sometimes God's answers look exactly like what we were hoping for. Other times, they reveal that God's love, wisdom, and creativity far surpass ours. To be aware of God's answers to prayer, we have to keep our eyes and hearts open. Be on the alert for answers to prayer today. When you catch sight of one, thank God. Allow the assurance of His everlasting care to encourage your soul.

Praying Today _____

..

..

..

..

..

..

..

..

There have been some things happening lately that I just don't understand, Lord. I know You see the bigger picture and that all that happens is part of Your plan; but sometimes I need a reminder. Help me focus on the promise that all things work together for good to those who love You. Help me see that You answer prayers.

Praising Today

SOLID GROUND

Those who trust in the LORD are like Mount Zion,
which cannot be shaken but endures forever.
PSALM 125:1 NIV

Alpine peaks endure sun and showers, heat and hail. They don't yield or bow to adverse conditions but continue to stand firm, being exactly what God created them to be—majestic mountains. God created you to be a strong, victorious woman. You were designed to endure the changing seasons of this life with God's help. Lean on Him when the winds of life begin to blow. God and His Word are solid ground that will never shift beneath your feet.

Praying Today _____

...

...

...

...

...

...

...

Dear Father, I've discovered that during times of stress, I seem more vulnerable. I need You even more during these trying hours. As I follow You and lean on You, You promise not to let my foot slip. You steady me and show me where there's solid ground to tread on. You watch over me constantly. And how grateful I am!

Praising Today _____

ETERNAL THANKS

I'll bless you every day, and keep it up from now to eternity.
PSALM 145:2 MSG

Eternal life isn't a reward we can earn; it's a free gift given by a Father who wants to spend eternity with the children He loves. This gift may be free to us, but it was purchased at a high price. Jesus purchased our lives at the cost of His own. His death on the cross is the bridge that leads us from this life into the next. Forever isn't long to say "thank You" for a gift like that.

Praying Today _____

There are many people in my family who have not accepted Your gift of salvation, dear Jesus. My most heartfelt prayer for each of them is that they trust You. Draw each of them into Your embrace. I pray that each would receive You as Savior.

Praising Today _____

GOD'S POWER

My life is an example to many, because you have
been my strength and protection.
PSALM 71:7 NLT

If people follow your example, where will it lead? Will they find themselves headed toward God or away from Him? As you allow God to change you from the inside out, your life will naturally point others in His direction. Being an example worth following doesn't mean you're under pressure to be perfect. It's God's power shining through the lives of imperfect people that whispers most eloquently, "There's more going on here than meets the eye. God is at work."

Praying Today _____

Lord, there are so many people in my community who either don't care about You or think they will please You by their own merit; but several of them don't truly know You. I ask You to open doors so I may witness to them. My prayer is that many will come to You.

Praising Today ————————————————————————

All Things for Good

Be brave. Be strong. Don't give up.
Expect GOD to get here soon.
PSALM 31:24 MSG

Trusting God can help transform you into a "glass half-full" kind of person. You can face every day, even the tough ones, with confidence and expectation because you're aware there's more to this life than can be seen. You can rest in the promise that God is working all things together for your good. You know death is not the end. In other words, you can expect that great things lie ahead. Why not anticipate them with thanks and praise?

Praying Today _____

An old hymn talks of praising You for Your matchless grace, and how could I go through a single day without doing so? I don't understand why You love and forgive me, but I wish to offer my sincerest thanks for these bountiful gifts. You are a wonderful Savior!

Praising Today _____

A Gift and an Action

*Lead me by your truth and teach me, for you are the God
who saves me. All day long I put my hope in you.*
PSALM 25:5 NLT

Faith is both a gift we receive and an action we take. God's Spirit gives us enough faith to reach out to a Father we cannot see. But as we continue reaching—continue putting our trust in God as we go through life—that little gift of faith grows stronger, like a muscle consistently put to work at the gym. Give your faith a workout today by doing what you believe God wants you to do.

Praying Today

God, Your desire is that we seek and do Your will, but You'll never force us to do it. You've laid unique paths before each of us, and it's because You love us all in a special way. Help us exercise faith and complete our work with joy.

Praising Today _____

Forever Faithful

The LORD is good. His unfailing love continues forever,
and his faithfulness continues to each generation.
PSALM 100:5 NLT

With time, we come to believe certain things are unshakable. The sun rises and sets. The tides ebb and flow. Seasons revolve year after year. Babies are born. People die. And the world goes on pretty much as it has for centuries: faithful to a predictable pattern. But there will come a time when the world as we know it will end. Only God is totally unshakable and unchanging. His love and goodness to us will remain forever faithful.

Praying Today _____

Lord God, I know that my hope for an amazing eternity with You is real because You are trustworthy. You never change Your mind, and You aren't capable of lies. Throughout the ages, Your promises have always been upheld. Because of this, I know that my hope of walking the streets of gold will not be disappointed.

Praising Today _____

LINKED BY FAITH

*You, God, . . .have given me the heritage
of those who fear your name.*
PSALM 61:5 NIV

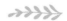

Your true lineage extends far beyond the branches on your family tree. That's because you have a spiritual heritage as well as a physical one. Your family line extends back through Old and New Testament times, around the world, and right up into today. You may know some of your brothers and sisters by name. Others you may not meet until you walk the streets of heaven together. But God's children are family, linked by faith and a forever future.

Praying Today _____

God, some of us hail from families with impressive legacies, and some of us have no family to speak of—or none we want to speak of anyway. I'm so thankful that while I can't choose my earthly family, I can choose Yours! I can become Your true child, with the legacy of promises and inheritance that awaits everyone in Your family.

Praising Today _____

Roller-Coaster Emotions

When doubts filled my mind, your comfort
gave me renewed hope and cheer.
PSALM 94:19 NLT

What are your emotions telling you today? You're unloved? Insignificant? A failure? Powerless to change? What you feel is not always an accurate measure of what is real. When your emotions try to take you on a roller-coaster ride, refuse to buckle yourself in. Ask God to help you sort through what's going on in your mind and heart. Cling to what God says is true, not to what your fickle emotions whisper on a poor self-image day.

Praying Today

Lord, this earth is a tumultuous place. It's a frenzy of emotions and circumstances that threatens to sweep us away into upheaval. But when frantic anxiety rises within me, I look to You. You are the Good Shepherd who leads me beside still waters and restores my soul. You are the Master of creation who looks at my storm and orders, "Be still."

Praising Today _____

GOD'S FAMILY GATHERINGS

I will give you thanks in the great assembly;
among the throngs I will praise you.

PSALM 35:18 NIV

There's beauty and power in drawing close to God each morning to talk to Him about the day ahead. But you are just one of God's children. Sometimes it's great to get the family together for prayer and worship. Every Sunday, in churches around the world, that's exactly what's happening. God's family is getting together for a thanksgiving celebration. Like any family get-together, your presence adds to the joy. So join in! God's Church wouldn't be the same without you.

Praying Today _____

Father, I often sit in church on Sunday and dwell on my anxiety and prioritize my to-do list when I should be remembering just how blessed You have made me. Help me make each Sunday and every day in between a day of remembrance, a day of fellowship, a day of counting blessings.

Praising Today —————————————————————————————

TRUE TREASURE

Do not be overawed when others grow rich,
when the splendor of their houses increases.
PSALM 49:16 NIV

It's been said that "money talks." Sometimes it yells. Loudly. What money can buy helps draw attention to those who have it and to those who would do anything to get it. But money says absolutely nothing about who a person really is—or how rich he or she truly is. You have riches that exceed what's in your bank account. Every relationship you invest in, be it with God, family, or friends, is a treasure that increases in value over time.

Praying Today ───────────────────────────

..

..

..

..

..

..

..

..

..

..

..

Money is fleeting and lasts only for this lifetime. I was longing for something more. But then I found You, my God. You held out a cup of living water that saturated my desiccated soul with new life—everlasting life. And You love me. I have found the "more" that I was seeking. It's You. I can't stop praising You for how You have saved me.

Praising Today _____

EMPTY CHALKBOARD

As far as the east is from the west,
so far has he removed our transgressions from us.
PSALM 103:12 NIV

Picture a chalkboard. Written on it is everything you've ever done that goes against what God has asked of you. What would you see written there? How big would the chalkboard be? Now imagine God wiping it clean with one swipe of His hand. Nothing remains, not the faintest image of one single word. That's how completely God has forgiven you. When guilt or shame over past mistakes threatens to creep back into your life, remember the empty chalkboard—and rejoice.

Praying Today _____

...

...

...

...

...

...

...

Lord, You love me even though I am a sinner. I will never be perfect on this earth. But I am forgiven. When You look at me You no longer see the ragged, dirty shreds of sin I was garbed in. Now You see the pristine, shining righteousness of Your Son. Father, fill me with Your love and allow it to overflow the borders of my life onto everyone I meet.

Praising Today

Absolute Acceptance

But let me run loose and free, celebrating GOD's
great work, every bone in my body laughing,
singing, "GOD, there's no one like you."
PSALM 35:9–10 MSG

Knowing you're loved without condition sets you free. It invites you to abandon insecurity, relax, and enjoy being yourself. It encourages you to go ahead and try, because failure is simply a steep learning curve. God's acceptance of you is the key to this freedom. As you rest in God's absolute acceptance, you'll discover the confidence and courage you need to push beyond who you are today and become the woman you were created to be.

Praying Today _____

..

..

..

..

..

..

..

Jesus, I have been a prisoner of my own despair, but no more! I'm leaving my chains and walking through the door of Your hope into freedom. You have wooed me with Your love, compassion, and faithfulness. I don't deserve Your attentiveness, Lord, but You've remained devoted to me despite my failures.

Praising Today _____

GREAT FRIENDS

And these God-chosen lives all around—
what splendid friends they make!
PSALM 16:3 MSG

Thank God for friendship. Literally. Spending time with those who understand how you tick, remind you what a wonderful woman you are, and challenge you to reach your God-given potential is one of life's greatest joys. The best way to have great friends is to be one. Pray regularly for the women God brings into your life, asking God to help you love them in ways that help you grow closer to each other and to Him.

Praying Today _____

..

..

..

..

..

..

..

..

God, I know that shaky feeling as I'm walking along a trail and I suddenly lose traction. But a friend reaches out and grabs my hand to steady me, and I find my footing once again. . . . God, along life's trail, help me lean on You and on the godly friends You've provided. Help me be that kind of friend too.

Praising Today _____

Plant a Seed

Your wife shall be like a fruitful vine in the very heart of your house, your children like olive plants all around your table.
PSALM 128:3 NKJV

There are many ways to be fruitful. One way is through relationships. Whether it's with family, friends, neighbors, church members, or coworkers, the things you say and do can be buds that blossom into something beautiful. Whom will you spend time with today? Each encounter is an opportunity to plant a seed. Will it be a seed of encouragement, grace, faith, comfort, or. . . ? Ask God to help you know the type of seed others need.

Praying Today _____

...

...

...

...

...

...

...

...

Father, You are my vinedresser. Snip off anything that doesn't bear fruit in my life for You. I know that without all the dead weight of old habits and selfish desires I will mature in my faith and bear the succulent fruit of Your Spirit, and I will be able to share the good harvest with others.

Praising Today _____

Your Very Own Story

*All the days ordained for me were written in your
book before one of them came to be.*
PSALM 139:16 NIV

The story of your life is written one day at a time. Every choice you make influences the chapters yet to come. But one thing is certain—the ending. Your future was written the moment you chose to follow God. That means the end of your story here on earth is actually a brand-new beginning. It's a story with endless chapters, a "happy eternally after" where tears are history and true love never fails.

Praying Today —————————————————————

..

..

..

..

..

..

..

..

..

God, it's not always clear to me what choices I should make, but I know that You will make it plain to me in Your time. My hope of salvation and eternity with You in heaven keeps me focused on Your purpose. You will never let me go, Father. You know what You are doing, and I don't drift aimlessly through my days when Your purpose propels me.

Praising Today _____

LOVING GENEROSITY

An evil person borrows and never pays back;
a good person is generous and never stops giving.
PSALM 37:21 CEV

Love and generosity are two sides of the same coin. Both put the needs of others before their own. Both give without expecting anything in return. Both make our invisible God more visible to a world in need. As our love for those around us grows, generosity can't help but follow suit. Today, take time to become more aware of the needs of those around you. Then ask God to help you act on what you see with loving generosity.

Praying Today

Father, I have realized that I need to adopt an attitude of thanksgiving, because if I allow one small snag to steal my joy, I miss the blessings flooding into my life. I have hope and peace and love through Christ. I have received mercy and grace. I am rich beyond measure in You! Open my eyes to the countless blessings I've been given.

Praising Today _____

A Gentle Shine

You have also given me the shield of Your salvation; your right hand has held me up, your gentleness has made me great.
PSALM 18:35 NKJV

A children's fable describes the sun and the wind making a bet: Which can get a man to take off his coat? The wind blows with vengeance, using its strength to try to force the man's hand. The sun simply shines, gently inviting the man to shed what he no longer needs. God does the same with us. His gentleness warms us toward love and faith. The closer we draw to God, the more we'll treat others as He's treated us.

Praying Today

Father God, remind me of Your long story of faithfulness to those who love and trust You. You do not belittle those who are struggling or bully us into believing. You have kept all Your promises throughout history. Give me wisdom to see Your truth and gentle love.

Praising Today _____

Something Good

*"Only you are my Lord! Every good
thing I have is a gift from you."*

Psalm 16:2 CEV

What is good about your life? Consider how every good thing we receive can be tied back to God. Family. Friends. Talents. The ability to earn an income. It's easy to take the good things in our lives for granted, while readily putting the blame on God when we feel things go wrong. The next time you notice yourself feeling happy about something good in your life, look for the part God played in sending it your way.

Praying Today _____

Loving Father in heaven, thank You for blessing me with so many good things. You haven't called me to an existence of joyless solemnity, but instead You came to give life—a full and everlasting life in You.

Praising Today _____

Wrapped in Grace

*For the LORD God is our sun and our shield. He gives us grace
and glory. The LORD will withhold no good thing
from those who do what is right.*

PSALM 84:11 NLT

When a gift is wrapped in grace, it comes with no strings attached. That's the kind of gift God gives. He doesn't hold eternal life just out of reach, taunting, "If you try harder, this can be yours." He doesn't promise to love us if we never mess up again. He doesn't say He'll forgive but refuse to forget. God graces us with gifts we don't deserve because His love is deeper than our hearts and minds can comprehend.

Praying Today ⎯⎯⎯⎯⎯⎯⎯⎯⎯⎯⎯⎯⎯⎯⎯⎯⎯

Father, when I come to You and say I'm sorry, You will always forgive me. I am unworthy of such acceptance, but You shower me in grace and mercy nonetheless. Help me to extend Your brand of forgiveness to others. I release any anger or grudges I've been holding, because You have forgiven me all my sins.

Praising Today _____

ACQUAINTED WITH GOD'S WORD

I praise you, LORD, for being my guide.
Even in the darkest night, your teachings fill my mind.
PSALM 16:7 CEV

Suppose you learn CPR in a first-aid class. Years later, when a child nearly drowns at a neighborhood pool, you spring into action. You know exactly what to do. The same is true with the Bible. The better acquainted you become with God's words, the more readily they come to mind when you need them most. When you're unsure of which way to turn, turn to the Bible. It will help lead you where you ultimately want to go.

Praying Today

Heavenly Father, the Bible is not just another collection of fairy tales. Every word of scripture is true and effective for teaching and encouragement. Thank You for writing down Your great story of the ages! You knew without it we would slip into despair. So You penned Your love and Your plans for us to spur us by hope toward endurance.

Praising Today _____

SPREAD HAPPINESS

You have helped me, and I sing happy songs
in the shadow of your wings.

PSALM 63:7 CEV

Happiness can be contagious. Why not spread some of yours around? Consider the ways God helps you nurture a happy heart. How has He comforted you, encouraged you, strengthened you? If you're happy, share it. Tell someone close to you what God has done. Smile warmly at those who cross your path. Surprise someone with a gift just because. Express to God how you feel in song. Thank God for the little things—such as the ability to feel happy.

Praying Today

You are pleased with me, Father. . .delighted to have me as Your child. You want happiness and goodness for my life, not suffering and turmoil. Reveal the lies I've been believing about You and teach me the truth You want me to know about Your unfailing love for me.

Praising Today _____

Your Body and Your Soul

My health may fail, and my spirit may grow weak,
but God remains the strength of my heart; he is mine forever.
PSALM 73:26 NLT

Your body is amazingly resilient, yet terminally fragile. Fashioned by God's lovingly creative hand, it was not designed to last forever. But *you* are. That's because you are so much more than your body. God cares about all of you, your body and your soul. Even if your health fails, He will not. He is near. He hears every prayer, even those you hesitate to pray. Call on Him. His hope and healing reach beyond this life into the next.

Praying Today _____

...

...

...

...

...

...

...

...

Father God, keep my soul thirsty for You and my desire strong to spend time with my Savior every day. I anticipate my moments and hours with You with eagerness. Like a parched desert wanderer, I crave a deeper relationship with You, the living God who gives me life.

Praising Today

MIGHTY AND LOVING

Do something, LORD God, and use your
powerful arm to help those in need.
PSALM 10:12 CEV

God spoke the cosmos into being. He fashioned the ebb and flow of the tides. He breathed life into what was once nothing more than dust. This same awesome God is reaching down to offer His help to you today. Perhaps your prayer is for your own needs. Or maybe it's for those you care about but don't know how to help. God is mighty enough, and loving enough, to do the impossible.

Praying Today _____

..

..

..

..

..

..

..

..

..

Lord, I'm exhausted by the struggle of this world. I've been trying to do it all on my own—and I've been failing miserably. I'm driven to my knees by weakness. I was about to collapse in hopeless despair—but then I looked up to heaven and I found You. The tireless Creator. The Strength Giver. Lord God, I trust You.

Praising Today _____

Open Up

Open up before GOD, keep nothing back;
he'll do whatever needs to be done.
PSALM 37:5 MSG

You can't keep a secret from God. He knows you inside and out. That doesn't mean you can't hold out on Him. There may be things you'd rather not discuss: areas of shame, bitterness, or rebellion. He'll never muscle His way into those parts of your heart. He's waiting for an invitation. If you honestly want real change in your life, don't wait any longer. Open up before God. Grace, forgiveness, and healing are yours for the asking.

Praying Today

Father God, You already know all about everything I've ever done, every misstep, every sin, every regret. And yet You still want me! You've forgiven me. You answered when I went looking for You, and You've delivered me from shame and replaced my sorrow with radiance. Instead of *outcast* and *reject,* You've given me a new name. You've called me precious daughter, the apple of Your eye. I no longer feel ashamed. I'm glowing with Your love and approval.

Praising Today _____

God's Best

Happy is he who has the God of Jacob for his help,
whose hope is in the LORD his God.

PSALM 146:5 NKJV

Some people place their hope in financial security. Others hope their popularity, abilities, or connections will get them where they want to go. Still others hope that if they want something badly enough, it'll just happen. But only those who place their hope in God can face tomorrow without any fear of the future. When you trust in God, you do more than hope for the best. You rest in knowing God's best is His plan for your life.

Praying Today _____

I've learned that You are my only hope, God. Only You can save. Only You can give me a promising future that's so much better than anything I could ever hope to experience here. Praise You, Lord, that there's more than this fleeting existence.

Praising Today _____

Reveal Your Majesty

*In your majesty, ride out to victory, defending truth, humility,
and justice. Go forth to perform awe-inspiring deeds!*
PSALM 45:4 NLT

Remembering that only God is God keeps us humble. Sounds simple
enough. But all too often we try to grab the wheel from God's hands
and steer our lives in the direction of what looks like it will make us
happy instead of simply doing what God asks us to do. Invite God
to expose any areas of your life where pride has you heading in the
wrong direction. Ask Him to reveal to you how big He really is.

Praying Today

Father, *submit* and *humble* are two words I cringe at reading in Your Word. Just like running into a coffee table in the dark, I've cracked the battered shins of my soul against the hard edge of my pride on numerous occasions. But You give grace generously to the humble. I have hope that through the power of Your Holy Spirit who dwells in me I can learn to quell my pride. I submit myself to You, Lord.

Praising Today _____

LIFE OF INTEGRITY

Joyful are people of integrity,
who follow the instructions of the LORD.
PSALM 119:1 NLT

Modern culture tells us that "bad girls" have all the fun. Don't believe it. A self-centered life is an empty life. When you choose to follow God and live a life of integrity, regret no longer knocks at your door. In its place you find joy. There are no worries about your past catching up with you or some half truth being exposed. You're ready to live life to the fullest, a life in which love and respect are freely given and received.

Praying Today _____

..

..

..

..

..

..

..

..

Thank You, Father! You have plunged me into a clear spring of water. Your Son's blood has scoured away all my sin until I'm sparkling and pristine before You. I no longer need to hide my ratty rags in the darkness. Instead I step into the light and come closer to You, assured by my faith in You that I have been washed and purified. You no longer see my past. Instead You see me draped in robes of holiness.

Praising Today _____

Joy Persists

Where morning dawns, where evening fades,
you call forth songs of joy.

PSALM 65:8 NIV

Happiness is usually the result of circumstance. Joy, however, bubbles up unbidden, often persisting despite circumstance. It's an excitement that simmers below the surface, an assurance that God is working behind the scenes, a contentment that deepens as you discover your place in the world. The more at home you feel with God, the more joy will make a home in your heart—a welcome reminder that God is near.

Praying Today _____

..

..

..

..

..

..

..

Lord, I may not always feel happy about my circumstances, especially when storms come, but the hope that I have in You, Jesus, sustains my joy through difficult times. May others see it bubbling inside me and be drawn to its warmth.

Praising Today _____

POWER OF WORDS

*Words of wisdom come when good
people speak for justice.*

PSALM 37:30 CEV

It takes courage to stand up for what's right, especially if you're the only voice speaking up in the crowd. But words have power. They can help bring injustice to light. They can encourage others to take a stand. They can incite change. But the right motive is just as important as the right words. Ephesians 4:15 (NLT) tells us to "speak the truth in love." Truth tempered with love is the perfect agent of change.

Praying Today

Father, give me greater understanding of the precious gift You bestowed on me. Allow me to spread the news of Your divine justice far and wide. Because You live in me, I can understand spiritual truths that baffle those who don't know You. The world is confused by You, Lord, because Your truth doesn't match worldly "wisdom." Thank You for giving me understanding, and help me bring others to You by speaking the truth in love.

Praising Today _____

A Bigger Plan

Discover for yourself that the LORD is kind.
Come to him for protection, and you will be glad.
PSALM 34:8 CEV

Kindness turns criticism into encouragement, bad news into words of comfort, and discipline into teachable moments. That's because kindness is concerned with more than results. It's also concerned with people's hearts. God's plan for you is bigger than being a "good person." God also wants you to be healed and whole. You can trust God to be a loving Father and not a callous taskmaster because the breadth of His kindness stems from the depth of His love.

Praying Today

Jesus, You were born in human form to share in our weakness and bloodline, and through Your perfect obedience You were able to redeem us. You willingly laid down Your life on the cross. Jesus, thank You for Your willingness to redeem us, to buy us back and provide us with a future. Thank You for Your love and abundant kindness.

Praising Today _____

INFLUENCERS

*Don't put your life in the hands of experts who
know nothing of life, of salvation life.*
PSALM 146:3 MSG

Those we choose to follow have power over us. Their influence can affect our actions, as well as our way of thinking. They can help draw us closer or steer us farther away from God. But sometimes we're not even aware of whom we're letting lead. Celebrities, experts in various fields, the media, charismatic friends—whose footsteps are you following? Ask God to help you discern who besides Him is worthy to lead the way for you.

Praying Today _____

Father, keep me from the mistakes of those who have gone before me. I give You my heart, my soul, my body, and my mind. Cleanse me of my stubbornness and unfaithful inclinations so I can follow You in obedience and love. You offer fresh hope for each generation.

Praising Today

What You Hear

I will instruct you and teach you in the way you should go;
I will counsel you with my loving eye on you.
Psalm 32:8 NIV

To learn, you have to listen. Are you really listening to what God is trying to teach you? Whether it's reading the Bible, listening to a message at church, or receiving counsel from someone who is farther down the road of faith than you happen to be, there is always more to learn. Prepare your heart with prayer. Ask God to help you clearly understand what you need to learn and then act on what you hear.

Praying Today ────────────────────

..

..

..

..

..

..

..

..

Lord, open the eyes of my heart. I want to know You with my whole being, not just have head knowledge of You. Send Your Spirit of wisdom and revelation to me so I can learn more about You and experience Your ways. Help me hear and respond in faith.

Praising Today

With Expectation

Who out there has a lust for life?
Can't wait each day to come upon beauty?

PSALM 34:12 MSG

God is amazingly creative and incomparably loving. Having Someone like that design a plan for your life is an exciting prospect. God promises there are good things ahead for you. That promise is enough to make each morning feel like a chest filled with treasure just waiting to be opened. Greet each new day with expectation. Invite God to join you in your search for the extraordinary treasures He's scattered throughout even the most ordinary of days.

Praying Today

You, God, put meaning into my existence. You have a plan. You created us to love You and have been working out Your purpose in generation after generation. Because of You I have an internal calm in a confusing world. My heart is filled with joy and peace because I trust You. I trust Your plan, and I trust that You have a future for me. Thank You for giving me peace, hope, and joy.

Praising Today _____

NEVER LONELY

I can always count on you—God, my dependable love.
PSALM 59:17 MSG

When you're feeling lonely, picture God beside you in the room. Talk to Him the way you would a dear friend. If praying aloud feels awkward, journal or write God a love note that you can tuck in your Bible. Read the book of Psalms. See what other people had to say to God when they felt the way you do right now. Remember, God is with you, whether you're aware of His presence or not.

Praying Today

Father God, the desert may seem barren and lonely, but You are always near. You don't abandon me there, but rather, You want me to praise You even in the wilderness. You are moving in my life even when I can't see You.

Praising Today _____

···

···

···

···

···

···

···

···

···

···

···

···

···

···

···

···

PERFECT LOVE

As high as the heavens are above the earth,
so great is his love for those who fear him.
PSALM 103:11 NIV

It's hard to grasp how deeply God cares for us because our firsthand experience of love comes from relationships with imperfect people. But God's love is different. With God, we need never fear condemnation, misunderstanding, or rejection. He completely understands what we say and how we feel—and loves us without condition. Since God is never fickle or self-centered, we can risk opening up every part of our lives to Him. We can risk returning the love He so freely gives.

Praying Today _____

..

..

..

..

..

..

..

Heavenly Father, Your perfect love drives away all my fears. How amazing that although my human relationships will inevitably disappoint me, *You* never will. I can have security knowing You love me unconditionally, and I can even love others better through the inspiration of Your loving-kindness toward me.

Praising Today _____

Undeserved Mercy

Surely goodness and mercy shall follow me all the days of my life;
and I will dwell in the house of the LORD forever.
PSALM 23:6 NKJV

In old-fashioned melodramas and classic films, repentant scoundrels throw themselves on the mercy of the court. This means they know that what they've done is wrong, that there's no possible way they can make it right, and that their only hope for redemption is to ask the court to extend what they don't deserve: mercy. God extends mercy to us each day. He's sentenced us to life—eternal life—and to the freedom to grow in the shelter of His love.

Praying Today

Jesus, You said that You didn't come to earth for the proud righteous, but for the bedraggled sinners who recognize their hopelessly wretched condition without You. I'm one of Your misfits, transformed by mercy into a marvelous new creation. Thank You, Father, for defending me in my vulnerability.

Praising Today _____

Divine Artwork

The LORD merely spoke, and the heavens were created.
He breathed the word, and all the stars were born.

PSALM 33:6 NLT

Genesis tells us how God spoke nothing into something. But that "something" was not just anything. It was the divine artwork of creation. All of creation, from the tiniest microbe to the most expansive nebula, is wonderful in the fullest sense of the word. Take time to appreciate the wonder God has woven into the world. Take a walk in a park. Fill a vase with fresh flowers. Pet a puppy. Plant a petunia. Then, thank God.

Praying Today

Lord of creation, I am in awe of the things You have done. Limitless—Your power, might, and wisdom are without border. My mind strains to understand exactly who You are. I know that I will never achieve a full knowledge of You here in this place, but I long to know more. You have done the most amazing things and set the most intricate plan into play for this world.

Praising Today

His Time, His Way

Be patient and trust the LORD. Don't let it bother you when all goes well for those who do sinful things.

PSALM 37:7 CEV

When we encounter conflict or injustice, we want resolution. We want relationships to be mended and wrongs to be made right. We want villains to pay and victims to heal. Now. Wanting this life to resemble heaven is a God-given desire. But the fact is we're not home yet. If you're impatient for a situation to change, pray for perspective, do what you can, then trust God for resolution in His time and in His way.

Praying Today

When I am tempted toward anger, Lord, Your Spirit nudges me to patience. When I want to lash out in spite when I'm slighted, I remember Your kindness. Before, I thought the status quo was the only way; now I know that I can nail my sinful nature to Your cross and walk away. I can walk in step with Your Spirit.

Praising Today _____

A PLACE OF PEACE

Love and faithfulness meet together;
righteousness and peace kiss each other.
PSALM 85:10 NIV

When you follow God's lead and do what you know He wants you to do, you discover a place of peace. Outward struggles may continue, but inside you can relax. You've done what you could with what God has given you—and that's enough. Listen for God's whisper of "Well done, My beautiful daughter." It's there. Rest in that place of peace and allow yourself to celebrate how far you've come and to anticipate what is still ahead.

Praying Today _____

Father God, I desire the peace that passes all understanding—peace that only comes from being in relationship with You. How much lighter my burdens are when I rest in the comfort of Your sovereignty over my life, rather than constantly fretting thinking I can figure it out on my own. Thank You for the perfect peace You alone can offer.

Praising Today _____

KEEP MOVING FORWARD

Count yourself lucky, how happy you must be—
you get a fresh start, your slate's wiped clean.
PSALM 32:1 MSG

It's hard to keep moving forward if you're dragging along baggage that weighs you down. God wants to help you discard what you don't need. Insecurity, guilt, shame, bad habits, past mistakes—leave them by the side of the road. Jesus has already paid the price for their removal. Once your past is truly behind you, you'll find it much easier to persevere. Tackling only one day at a time is downright doable with God's help.

Praying Today _____

Heavenly Father, You are the Burden Bearer. Your Word says that You will daily bear my burdens. Father, Your shoulders are broad and strong, and I feel oh-so weak right now. I'm handing over my stuff. Take it and rejuvenate my joy in a Savior who is able to carry my load. Thank You, Father, for Your compassion! My soul feels so much lighter now that You've relieved me.

Praising Today _____

God's Power in You

*My power and my strength come from the LORD,
and he has saved me.*

PSALM 118:14 CEV

Moses parted the Red Sea. Peter walked on the waves. David dispatched a giant with a single stone. God's power was the force behind them all. How will God's power work through you? Perhaps you'll conquer an addiction, face your fear of public speaking, forgive what seems unforgivable, serve the homeless, or lead someone into a closer relationship with God. When God is honored through what you do, you can be sure His power is at work in you.

Praying Today

Lord God, I trust You. I trust Your understanding of every impossible and strength-sapping situation I'll ever encounter, and I give them to You. I'm off-loading my stress onto the wide span of Your strong shoulders. I can do nothing without You. Pour new strength into my weary body. I want to soar like the eagles and work zealously in Your kingdom.

Praising Today _____

REASON FOR PRAISE

Better is one day in your courts than a thousand elsewhere.
PSALM 84:10 NIV

What words would you use to describe God? *Loving. Forgiving. Powerful. Creative. Wise. Merciful. Eternal. Glorious. Dependable. Truthful. Compassionate. Faithful. Friend. Father. Savior.* Every word you can think of is reason for praise. When you pray, share more than a list of requests with God. Tell God how much He means to you. Choose one attribute of God and tell Him how that character trait has made a difference in your life.

Praying Today _____

You, Lord, do not shift. You're comfortingly always the same as You were yesterday. And You'll still be the same tomorrow as You are today. Your Word does not alter. I can hold any trendy new belief against the ageless pillar of scripture and determine its truth. Your unshifting character brings hope to my faith because Your promises of old will forever be upheld.

Praising Today _____

A Conversation

*I've thrown myself headlong into your arms—
I'm celebrating your rescue. I'm singing at the top
of my lungs, I'm so full of answered prayers.*

PSALM 13:5-6 MSG

When we pray, we expect things to happen—and they do. Inviting the Creator of the universe to be intimately involved in the details of our day is a mysterious and miraculous undertaking. But prayer isn't a tool. It's a conversation. God is not our almighty personal planner, helping us manage our lives more efficiently. He's Someone who loves us. When you pray, remember you're speaking to Someone who enjoys you, as well as takes care of you.

Praying Today _____

..

..

..

..

..

..

..

You are a God who hears and answers. Maybe not on my timeline or within my plans, but You do answer. Give me patience, Lord. I will wait for You, Father, because I trust that You are even now working out the answers. And in the meantime, I'll simply wait *with* You.

Praising Today _____

GOD IS NEAR

I cry to God to help me. From his palace he hears my call;
my cry brings me right into his presence—a private audience!

PSALM 18:6 MSG

It can be difficult to picture yourself in the presence of Someone you cannot see. But the Bible assures us God is near. His Spirit not only surrounds us but also moves within us. When God's presence feels far away, remember that what you feel is not an accurate gauge of the truth. Read Psalms to remind yourself that others have felt the way you do. Then, follow the psalmists' example. Continue praising God and moving ahead in faith.

Praying Today _____

..

..

..

..

..

..

..

..

..

When I need Your help, Father, You come close to me, just as You have drawn near to others in their times of trial throughout the ages. It is a great comfort to know that You will be here beside me when I need You and will lend me the strength I need to get through the hard times.

Praising Today _____

DIVINE PROTECTION

*Let all who take refuge in you be glad; let them
ever sing for joy. Spread your protection over them,
that those who love your name may rejoice in you.*

PSALM 5:11 NIV

In Old Testament times, God designated cities of refuge. These were places where people who'd accidentally killed someone could flee. Here they'd be safe from the vengeance of angry relatives until they had received a fair trial or had proven their innocence. God is a place of refuge for His children. No matter what happens, you're under God's protection. Flee to Him in prayer when you feel under attack. God provides a safe haven where truth will be brought to light.

Praying Today _____

...

...

...

...

...

...

...

The beginning of all things and the end of all things, Father, You are an eternal Being who was and is and will always be. And You're here with me. You've chosen me and loved me. In protection You crouch over me, Lion of Judah, and roar at the enemy, "Mine!"

Praising Today _____

Countless Gifts

He covers the heavens with clouds, provides rain for the earth,
and makes the grass grow in mountain pastures.
PSALM 147:8 NLT

God provides for us in so many ways that it's easy to take them for granted. The fact that the sun rises each morning, encouraging crops to grow, or that our hearts take their next beat and our lungs their next breath are just a few of the countless gifts we receive from God's almighty hand. As you go through the day, consider the big and little ways God meets your needs. Then take time at day's end to give thanks.

Praying Today

God, I am saved. I am redeemed. I am chosen. I am forgiven. You love me so much that You gave Your life in ransom for mine and are even now preparing a beautiful home for me in eternity. I don't deserve any of this! In fact, what I deserve is punishment, but You've given me grace instead. And on top of Your mercy You've poured good gifts on me.

Praising Today

A Unique Spot

I cry out to God Most High,
to God who will fulfill his purpose for me.
PSALM 57:2 NLT

A beautiful woman like yourself was created for more than decoration. You were created for a purpose. Your purpose is not a specific job God has designated for you to accomplish. It's more like a unique spot He's designed for you to fill. God is working with you, encouraging you to grow into this "sweet spot." As you learn to lean on Him, God will help you discover the true joy and significance that come from simply being you.

Praying Today

Father, Your Word tells me that I'm more than a castaway creation. Your Word says that I *have* been chosen—by You. I may have been orphaned by this world, but You picked me to be Your precious daughter, adopting me into Your family. There I have found acceptance and grace unlimited. I have found a place to belong and be loved for all eternity. I've discovered a Father who loves me and sees me as holy and blameless and cherished.

Praising Today _____

Your Focus

Keep company with God, get in on the best.
PSALM 37:4 MSG

Sometimes, drawing close to God can feel like an eternal to-do list instead of a relationship. If praying, reading scripture, going to church, or serving others begins to feel like just another task, don't settle for checking them off your list. That's ritual, not relationship. Instead, make a date with God. Set up a time and place. Then simply talk and listen. Focus on who God is. Take the time to fall in love with Him all over again.

Praying Today

Father, I need You to whisper, "Be still," into the churning waters of my soul. Give me rest as I focus my thoughts on You. Your Word says that You will keep in perfect peace those whose minds are steadfast, because they trust in You. I trust You, God. I trust in Your goodness and mercy. I will firmly fix my eyes on You amid the distractions of life and feel Your presence wash over me.

Praising Today

RENEWAL

Weeping may stay for the night,
but rejoicing comes in the morning.
PSALM 30:5 NIV

Renewal isn't taking a deep breath, smiling through gritted teeth, and muscling your way through today. Renewal is a kind of rebirth. It's letting the past fall from your shoulders and welcoming hope back into your heart. Renewal is a work of the Spirit, not a state of mind or act of the will. It's joining hands with God and moving forward together, expectant and refreshed. Are you ready to release whatever's holding you back and reach out to God?

Praying Today _____

..

..

..

..

..

..

..

..

Lord, You call this life light and momentary trouble—a passing discomfort that will earn me eternal glory! Instead of straying to the temporary, may my mind be locked on the eternal. Then I will live for You, undaunted by my earthly circumstances, and my soul will be renewed.

Praising Today _____

Respect

But I, by your great love, can come into your house;
in reverence I bow down toward your holy temple.
PSALM 5:7 NIV

It's true God is our Friend. But He's more than our BFF. God is our sovereign Lord and King. He's the One who initiated this implausibly intimate relationship: Creator with creation. God's overwhelming love for us should not lull us into a familiarity that disregards reverence and respect. There will come a time when every knee will bow to Him. Until that day, may our awe and esteem continue to grow right along with our love.

Praying Today _____

..

..

..

..

..

..

..

..

Heavenly Father, You offer me an awesome spiritual life that will last forever. I am alive in You, Jesus, and it is deep and quenching and free. It's far more amazing than anything I could ever imagine. I love You so, and I bow in worship of You!

Praising Today _____

Rest and Relaxation

Whoever dwells in the shelter of the Most High
will rest in the shadow of the Almighty.
Psalm 91:1 niv

Picture a hammock in the shade of two leafy trees, swaying gently in the breeze. Now picture yourself nestled there, eyes closed, totally relaxed. This is what it's like to rest in the shadow of the Almighty. Knowing that God holds you tenderly in His hand, offering protection, comfort, and grace, allows you to let go of your fears and concerns. God knows about them all. Rest in the fact that scripture says nothing is impossible with God.

Praying Today

God, navigating this world is exhausting. But my weary soul has found a resting place in You. I will not be shaken, because I have sunk my foundation into Your bedrock. God, You are solid ground when others wash out. The enemy may assault me, he may rattle my defenses looking for vulnerabilities, but You are my fortress. Thank You, Jesus, for bolstering my shaky walls and giving me a place of refuge.

Praising Today _____

Right Rewards

By your teachings, Lord, I am warned;
by obeying them, I am greatly rewarded.
PSALM 19:11 CEV

Doing the right thing comes with its own rewards. Whether it's the actual Ten Commandments or other teachings found in scripture, following what God says is right points the way toward loving relationships and a balanced life. Obedience comes with the added bonus of a guilt-free conscience and the knowledge that we're living a life that pleases the Father who so deeply loves us. These are rewards that won't tarnish with the passing of time.

Praying Today _____

...

...

...

...

...

...

...

...

Heavenly Father, You reward Your faithful followers in this temporary life. When I am beat down from the struggle, remind me that this life is a pinprick in time. But what I do with this speck of time will impact my eternity. I long to hear "Well done, My good and faithful child" when I see You face-to-face.

Praising Today ⸺

Righteousness in Action

Blessed are those who keep justice,
and he who does righteousness at all times!

PSALM 106:3 NKJV

Living a moral life, a life that honors God and those around you, is righteousness in action. It's the opposite of self-righteousness. That's a life where you justify doing what you deem right, regardless of whether God agrees with your assessment. Righteousness, however, reflects God's own character. It shows you truly are His child. Your actions are not swayed by emotion, peer pressure, or personal gain. You do what's right simply because it's the right thing to do.

Praying Today

I want You, Jesus, and only You. Nothing else matters except knowing that I belong to You. My hope and righteousness arise from my faith in You. May I measure everything I allow into my life against Your standards and rid my life of anything that doesn't measure up.

Praising Today

THE ULTIMATE SACRIFICE

*I am God Most High! The only sacrifice I want
is for you to be thankful and to keep your word.*
PSALM 50:14 CEV

In the Old Testament, we read about God's people offering sacrifices to pay the price for their rebellion against God. In the New Testament, these sacrifices disappear—except one. When Jesus willingly went to the cross for us, He became the ultimate sacrifice. His death paid for the wrongs we've done once and for all. Each time we choose to follow God instead of our own hearts, we offer a sacrifice of thanks in return for all Jesus has done.

Praying Today _____

We can't add anything to the beautiful simplicity of Your grace, Father. Jesus was enough then, and He's enough now. His sacrifice was sufficient for my sin—all of it. I can never go so far that Your grace won't cover me. And that will never change because You never change. Strengthen my heart with Your amazing, boundless, wonderful, and completely undeserved grace.

Praising Today _____

A Fresh Look

Satisfy us each morning with your unfailing love,
so we may sing for joy to the end of our lives.
PSALM 90:14 NLT

Each morning when you rise, take time to turn your eyes toward the Son. Take a fresh look at what Jesus has done out of love for you. Recall what you've been forgiven and the many blessings you've received. Consider how following in Jesus' footsteps has changed the direction of your life—and will change the day ahead. Allow gratitude to wash over you anew. There's no greater satisfaction than seeing your life in the light of God's great love.

Praying Today _____

Heavenly Father, at times I look around and wonder why I'm striving to do the right thing. Why I'm working so hard to follow You in a corrupt world when it seems like everyone who simply lives for themselves is getting so much more out of life than I am. But then I remember Jesus. He endured more than I ever will for the joy awaiting Him in eternity. And because He did, I can persevere for the promise.

Praising Today _____

Proper Alignment

You open your hand and satisfy the desires of every living thing.
PSALM 145:16 NIV

Our hearts are needy. They cry out for love, relief, pleasure, and purpose. They cry out for what they see on TV. Only God can quiet their relentless cry. That's because God is what they're actually crying out for. As we open our hearts more fully to God, we'll see more clearly that our needs are being met. What's more, we'll notice that our desires are changing, aligning themselves more and more with God's own.

Praying Today

Father, You shield the weak and heavy-laden of Your flock, and You are gentle with me when I need special care. Open my eyes to the ways You are caring for me even now. You know my needs and give me just the right amount of strength to get through my difficulty. I am never alone. Your eye is always on me. Forgive me for complaining instead of trusting.

Praising Today

LIMITLESS

The LORD is truthful; he can be trusted.
PSALM 33:4 CEV

God's power is limitless. That's tough to comprehend. But knowing God has the ability to care for us in any and all circumstances is not the true reason why we can feel safe and secure in His presence. Being in the presence of a beefy bodyguard only feels safe if you know that person is trustworthy, if you know he's on your side. God is on your side, fighting for you. You can trust His strength and His love.

Praying Today

Heavenly Father, when You ask me to do something that I don't understand, may I step forward as a willing vessel in complete trust, knowing that You have the power to accomplish what You say You will do and that Your goodness is unparalleled. I praise You, God, for You have filled me with hope through Jesus.

Praising Today _____

LOVING THROUGH SERVING

Make my heart glad! I serve you, and my prayer is sincere.
PSALM 86:4 CEV

The people we love we serve. If a friend's car breaks down, we give her a lift. If she's ill, we make her family a meal. We may use the word *help* instead of *serve*, but the result is the same. Love leads us to act. As our love for God grows, so will our desire to serve Him. One way we serve God is to care for those He loves. Ask God whom He'd like you to serve today.

Praying Today _____

Father God, thank You for the divine weapons you equip your servants with: faith as our shield against hopelessness; truth as our belt; salvation as our helmet; righteousness as our body armor; and Your Spirit and Your Word to engage the enemy in combat. Thank You for Your protection and provision for the spiritual battle we endure. Keep my mind locked on You as I serve others in Your name.

Praising Today

Savor Today

I think about you before I go to sleep,
and my thoughts turn to you during the night.
PSALM 63:6 CEV

Close your day in a wonderful way by spending it in your Father's arms. Instead of allowing your thoughts to race ahead toward tomorrow, take time to savor today. Regardless of whether it's been a day you'll long remember or one you'd rather forget, ask God to help you recall what matters. Thank Him for His loving care. Ask forgiveness for any moments when you turned your back on Him. Then relax and rest, knowing He's near.

Praying Today _____

Father, because I'm one of Your children, I am undefeated every day. Satan may try to convince me to worry and attempt to control tomorrow, but all I need to do is remember that You're greater than my fears. Greater than my failures. Greater than my hurts. And I belong to You. I can find peace at the end of even my worst days if I always cling to that.

Praising Today _____

A WELCOME SOURCE

Set a guard over my mouth, LORD;
keep watch over the door of my lips.
PSALM 141:3 NIV

The words we speak have power. They can hurt or heal, repel or attract. They also provide a fairly accurate barometer as to what's going on in our hearts. If you find words slipping out that you wish you could take back, return to the source. Ask God to reveal what's going on in your heart. With God's help, your words can become a welcome source of comfort and encouragement to those around you.

Praying Today

Heavenly Father, You promised to comfort those who grieve over the sins they have committed against You. So often, my sins are a result of careless words. When we realize our great need for You and hunger and thirst to know more of You, You will satisfy us with the bread of life and living water. When I'm in closer relationship with You, my words will be more thoughtful.

Praising Today _____

SEASONS

"Be still, and know that I am God."
PSALM 46:10 NIV

What season of spiritual growth are you in? Springtime's early bud of new love? Basking in summer's sunshine, growing by fruitful leaps and bounds? Knee-deep in autumn, with remnants of your old life falling like dead leaves around your feet? Or praying your way through winter, where God and that joy of first love seem far away? Whatever season you're in, remember: God is the only One who can make something grow. Trust His timing and watch for fruit.

Praying Today

"Winter" can be the hardest spiritual season. When my heart is broken, You are near, Father. You soothe me with words of comfort. Others may not have time to listen when I need to pour out my heart and sort through my emotions, but You always have time for this daughter of Yours. You are always full of wisdom and help me decide which way to turn, whether to take action or to be still and allow You to work. Help me as I wait for spring's bloom.

Praising Today _____

A Fresh Page

I feel put back together, and I'm watching my step. GOD rewrote the text of my life when I opened the book of my heart to his eyes.
PSALM 18:23–24 MSG

God can rewrite your life's story line. It's true that what's done is done—God won't change the past—but He can change how you see it. He can reveal how He has woven themes of redemption and blessing throughout what once looked hopeless. He can also change how the past affects you. Through His power, God can free you from the bondage of bad habits and past mistakes. As for the future, that's a fresh page. What will God and you cowrite?

Praying Today ⎯⎯⎯⎯⎯⎯⎯⎯⎯⎯⎯⎯⎯⎯⎯⎯⎯⎯⎯⎯

What hope and joy would we have if the short span of our years here winked out with our final breath and then there was nothing—no glorious streets of gold, no eternity with You and our loved ones in Christ, no greater purpose for our existence than our own selfish ambitions? Without You, we would have no forgiveness or hope of redemption. But You have given us a new hope. The promise of more. The promise of being with You in a perfect place where pain and sin no longer exist. You have given us forever.

Praising Today _____

OVERCOMING

You are my strength, I watch for you; you, God,
are my fortress, my God on whom I can rely.
PSALM 59:9–10 NIV

Some people believe that if they follow God, life will be trouble-free. Jesus doesn't seem to agree. In John 16:33 (NIV), Jesus says, "In this world you will have trouble." But Jesus doesn't leave it at that. He continues, "But take heart! I have overcome the world." Don't be surprised when struggle comes, but don't lose heart either. God will provide the strength you need when you need it to help you overcome whatever comes your way.

Praying Today _____

..

..

..

..

..

..

..

..

Instead of being surprised and discouraged by my struggles, I return to You and receive Your grace, Lord. You have won the victory already, and You have made me into an overcomer. I can overcome this world of sin because I believe that You, Jesus, are the Son of the most high God.

Praising Today

Turn Your Thoughts. . .

I try to count your thoughts, but they outnumber the grains of sand on the beach. And when I awake, I will find you nearby.
PSALM 139:18 CEV

Trying to comprehend an infinite God with a finite brain can leave you feeling small. That's okay. Compared to God, we are small. But when we balance the fact that a God too big for our brains to hold cares for us with a love so deep that nothing, absolutely nothing, can come between us, we find peace, as well as perspective. Turn your thoughts toward God, and your heart can't help but follow.

Praying Today ⎯⎯⎯⎯⎯⎯⎯⎯⎯⎯⎯⎯⎯⎯⎯⎯⎯⎯⎯⎯⎯⎯⎯⎯⎯

God, You know me. You know everything there is to know about me, from my deepest thought to every freckle on my skin. You know my character and my actions. You're familiar with each and every habit I entertain. You know how I like my coffee, and You also plumb the depths of my love for You. You see the good in me, and my darkest moments are revealed to You. And yet, knowing all the secrets about me that You do, You still rest Your guiding hand of love upon me.

Praising Today _____

SCRIPTURE INDEX

Psalms

MORE MUCH-NEEDED ENCOURAGEMENT FOR GROWING YOUR FAITH

Unafraid / 978-1-64352-415-3
Untroubled / 978-1-68322-946-9
Unashamed / 978-1-64352-192-3
Unhurried / 978-1-68322-599-7
Unfinished / 978-1-68322-747-2

These delightful devotionals will refresh and renew your spirit,
filling your heart with the assurance that only God can
provide today and for all your days to come!

Hardcover / $12.99 each